Fascinating Panoptic Septon

Fascinating Panoptic Septon

The September-born Poem

Ajarn Wu Hsih

PARTRIDGE

A Penguin Random House Company

To order additional copies of this book, contact
Toll Free 800 101 2657 (Singapore)
Toll Free 1 800 81 7340 (Malaysia)
orders.singapore@partridgepublishing.com

www.partridgepublishing.com/singapore

Acknowledgement

The author would like to extend his sincerest gratitude...

to his Guru Shrii Shrii A'nandamúrtiji (composer of 5018 songs called Prabha'ta Sam'giita, profounder of the Neo-Humanism and ProUT) for inspiring most of his Septons, to A'ca'rya Sarvabodha'nanda Avadhuta, his loving parents, Tatang Diosing and Inang Nena,

his fellow Septonists who contributed their Septons in this book and for carrying out the torch of Septon poetry: Ainjali Chow, Jeannie Carrera Chow, Prof. Amado Mendoza, Jr., Aine Lozauro, Franco Sangreo, Prof. Alexander Samson, Roy Mark Corales, Khadijah Maricar Bulawin, Manuel Ambrocio, Joven Ramirez, Carmencita Aquino, Roberto Calingo, Estrella Marie Bojare, Joey Fernandez, Gemma Duldulao, Olivetti Millado, Francis De Chavez, Corazon De Luna, Ronald Marzona, Mac Adrone Adonay, Joy Gallardo, Annabelle Cahanding, Hiroshi Taniuchi, Sunanda Eng, Parameshvarii Linda May, Hon. Mayor Oswald Valente, Josie Rituerko, Marlon Rodrigo, Ven-Lyn Atiagan, Allan Sasotona, and others who are not mentioned but are very much appreciated,

to great poets like Doc Penpen B. Takipsilim(creator/inventor of Pentasi B) together with world famous writer and author Ms. Caroline Nazareno for opening the door of Pentasi B Visual Poetry and encouraging the author to create visual poems,

to the prolific Ilokano author and educator Dr. Aurelio Agcaoili of the Nakem International for the encouragements,

his former teachers that paved the way of learning and his students that inspired the author to write,
and last but not the least, to his wife Emma and his children Jhoanne Ayen, Carlos Jose, Jose Gio and Fatima Joseya Mae,

Om... Ba'ba' Na'm Kevalam!

-Ajarn Wu Hsih

Introduction To Septon Poetry

WHAT IS SEPTON?

It is a September-born poem which is related with number 9, compressed or not. It is adapted from the word September because it was on the 18th of September 2007 that Septon poem was born.

WHAT IS A COMPRESSED NUMBER?

A compressed number can be derived from adding digits of the numbers like 18, 27, 36, 108, 9-9-9, 4-6-8, 6-6-6, 4-3-2, so on and so forth. The compressed number is used as external characteristic such as definite or total number of letters, syllables, lines, stanzas, etc.

SEPTON is a continuously evolving poem.

It is a synthesis of classical and modern style. Its fulcrum is the nonet. It has subtypes like Kúryu and more. It has the soul of classical poetry and a body of modern expressions. It is a riverbank that can hold the surge of a wildest river of poetic creativity yet pliant as the bamboo grass. It is as ancient as music and as ever new as wisdom!

"Septon: the September-born poem"

September poem
mimicks infinite rhythm
embled circumroute

September rain
mourning o'er the reign of death
and is resurrected 'gain

September moon
in twenty zero seven
kiss'd the eighteenth sun

Contents

1. Ajarn Wu Hsih's Septon Poems

The following are the Septon poems written by the author which began in 2007.

1. "Lady"

Oh ever beauteous numeric lady, tell.
Is it, in the heav'ns a sin to love, too well?
Today from the womb, thy natal day fell.
In his mind thoughts of thee eternally dwell.
Quaffing the stillness with thy scentuous smell.
Pleading, his agonizing heart, with pity quell.
From beginninglessness, he longeth for thee.
Tho' to endlessness from him thou'd e'er flee!
Wilt his soul roam 'til thou and him uniteth in glee.

2. "A Man without A Heart"

I was surprised to know one day,
When I found out my heart is astray,
Searching, looking for its lost piece,
Gone with the beloved, who went overseas.
Since then, it never became at ease,
For it already lost its half before,
When it has encountered a woman to adore,
And so, now I'm a man without a heart,
For once again, I lost its remaining part.

3. "Alone With Luna"

Listening to the rain as mine mind delve deep.
With a warm blanket and mine arm as pillow to sleep,
Inquired I why minds go to unconscious realm, peep?
Cannot eternally the ever blissful status keep?
'Yond the mango leaves in reverie turn'd I mine sight.
Ah! Luna(moon), thou art whole yet I am lacking a thing tonight.
Cannot I attain the "Supreme Stance" lest with a fight?
Listen! let thy infrared glow shine mine path alight.
And makest thou mine journey steady and my goal e'er bright.

4. "Bliss"

Come, come, come, I am waiting, my Bliss,
Deep in the innermost chamber of my mind's peace

I have opened the secret gates for you, so come!
Unbearable time passes by, leaving me in gloom
In this seemingly hopeless six-cornered room.

The laborers are now complaining
The knights no longer nobly fighting
The merchants are all voraciously hoarding
The magistrates, the goal, are no longer showing.

5. "Bliss Personified (Shrii Shrii A'nandamúrti)"

I know that Love does not obey any logic.
In loving Thee my LORD, my soul is ready to mimic,
Individuals whom for Love, gave their all even ending tragic.
I have searched for Thee in all ten direction.
In searching for Thee oh! Endless One, defied all humiliation.
Insidiously pleading for an iota of compassion.
I and Thee, my LORD, shall forever play hide-and-seek?
In robustness of my youth or e'en when I'm old and sick.
Infinitely, Thou art my LORD, BLISS personified, always meek.

6. "Bliss, Bless"

Existence, Expansion, and Experience of bliss,
The fruit of an enlightened and synthetic analysis,
Nothing is neglected in this careful and humane assess,
This is the physical, psychic and spiritual dimensions of social progress.
Holistic knowledge of Truth is a must to acquire and possess,
To waste not much of physical vigor and mental prowess,
And collectively, we'll attain spiritual limitlessness,
Not by doubting and fearing nor by stupefying guess,
Can lead the society and us, G.O.D. will bless.

7. "All are God's"

A wise sage is he, who knows and knows he knows.
If you find one --- follow him!
Asleep is he, who knows and knows not he knows.
If in nightmare --- awake him!
An innocent child is he, who knows not and knows he knows not.
If at lost --- guide him!
A worst fool is he, who knows not and knows not he knows not.
If destructive --- hedge him!
A sage; a child; a fool; asleep? All are GOD's and are in HIM.

8. "Bow and String"

I'm the bow and you are the string
Our goal the target and the arrow a thing
That swiftly flies in full swing
Hitting the target with a heavenly blessing
Such is our relationship, isn't it a perfect pairing?
When the time of the arrow has come to an aim
Stretched be the string to a direction, the bow bends the same
Striking life's target in shame or in fame
Will you be with me, my lovely and most cherished dame?

9. "Come Home"

The love, the love, the love, saccharinely sweet
Sweeter it'll be on the day again we meet.
Together we will share sweet love on love's seat
Sweet love, sweet love, I'll lay all at your feet.
I plead, I implore, come home now or soon
Or let it be in the night of the ninth full moon.
I'll play the sweet sound, your favorite tune
Own the night, we'll dance 'til the morning light
I'll hold you in my arms, close and so tight.

10. "Come, Let Me Be"

In clashes and cohesions, whate'er the case may be.
I am who/what I am and please let me just be me.
If only you'd trust me enough, behold and see!
I am a Zoetrope who knows both love and fury.
Come along! Tread life with me, be not in a hurry.
If hastily you'll stride, surely you'll be sorry!
For mortal life is full, full of unprognos'd surprize.
Deep secret -mystery, as well as hateful lies.
If you search Earth below, even soar yonder skies!

11. "In My Loneliness"

In my loneliness I caught a glimpse of swift fleeting cloud.
Asking me question piercing through my ears aloud,
"Why are you so lonely, aloof from the crowd,
Loneliness and sadness to yourself allowed"?
"Please, leave me alone, I mean no offense"!
Replied I to querying cloud in pretense,
'Cause mine belov'd left me in pain so intense.
Oh! What kind of life is this?
Always caught I in a quagmire of mess!
Would G.O.D. still let be happy, bless me someone to caress?

12. "Let the Sun Rise"

Listen to the beat and rhythmic tunes
Announcing the renaissance of Indio's in runes
Heaping sands of Hope as in dunes
In the hearts and minds of Indios, let the Sun rise
Unity reign, coordinated-cooperation precise
Pave the way for communism's and capitalism's demise
In Progressive Socialism, all demands' supply suffice
The earth's fruit is all ours to keep
Let not any family in poverty and hunger sleep.

13. "MAHARLIKA: small but great in spirit"

MAHARLIKA: "Small but great in spirit".
Archipelago envied, lying in the Orient-east.
Haven of Maharlikans the adorers of Life, of Bliss.
Abode of the gods, immortal as the seas…
Raging waves against tyranny, guarding people's dignity.
Land teeming with verdant flora and fauna for humanity.
Islands and nations far-and-wide will hear,
Knights' shout for sweet freedom, advancing without fear!
Armed with liberating ART as sword and spear.

14. "Live Simply"

Be firm, oh Maharlikans in the lofty struggle!
In Neo-Humanism's eloquence do not e'er wobble.
In establishing ProUT community, shrink not from hurdle.
Cling not and desire not for lucrative cloak ar mantle.
strive to be contented and make your mind e'er subtle.
Think not what you can get, instead, what you can give.
And not so common adage we opt to follow and believe.
In so doing, a collective welfare we will soon perceive.
"Live simply, so that others may simply live."

15. "Love -In Proper Time, Place & Person"

I thank the LORD for sending you to me,
For you and I were meant to be.
We have a bond too strong to break,
We have a love no one can take.
In you, I found a love so true,
Full of optimism, you changed my view.
That when love fails and breaks your heart,
Ruins all your dreams or tears 'em apart,
Love'll mend it in Proper time-Place-Person, ne'er to depart.

16. "Love Sublime"

Love exists in a realm sep'rate from rationality and irrationality.
Operating in world of untainted arationality.
Only he who has tasted it can understand its reality.

Love appears in the eyes, a canvas painted with varying hue.
With it, heroes die, kingdoms they subdue.
Will all lovers their beloved, persistently pursue.

Love inspires the Septons, poets always write.
Stringing words and lines together with all love's full might.
Should in love's platform, the poet, the reader, and all must unite.

17. "Methodology"

Neither I know nor I know, is the must query
But, what do I truly know, is the fundamental one for scrutiny.
How can I be sure of knowing anything?
Is there anything that can be evidently known in knowing?
To accept as true nothing not known to be evidently so.
To divide each difficulty partially, in solving better, too.
Highest wisdom is in discovering the first cause of all causes.
And understanding true principles embedded in Nature as bases,
This(methodology) will verily relieve one from any known lapses.

18. "My Vow"

Oh Maharlika, a dame so fair!
A lovely woman I love to stare,
To leave her I would not dare,
'Cause to me she is a jewel very rare;
A masterpiece that needs a loving care,
And to no one I would not share,
For I so love her ocean deep,
And promise not to make her weep,
To her my vow I'll certainly keep.

19. "No One Else To Cry On"

I choreograph thoughts but ne'er my heart with lies,
Not as a cunning disguiser who tends to be so nice,
I do hide away my pains, not only twice or thrice?
Pray'd I this life even be made concise,
Hurt feelings, unruly emotions; These my silence invade.
Frustrations, demolished dreams of sweet love don't fade,
Wondering still, how and why circumstances made...
Me into a soul sliced with dagger of duo-blade?
And Left me with no one else to cry for a soothing aid.

20. "Of Nature's Nature"

Of Nature's nature, there is always more to say.
The beauty of Her inconsistencies yet consistently She sway.
Try the minds of all thinkers tracing all Her ways,
Gone are thinkers yet Nature perpetually stays.
Cycle upon cycles and law upon laws,
The great Scheme unerring, erring sometimes She goes.
But lo! She is a wife, might of Her consort.
She's owned by the Supreme Consciousness, Her eternal cohort.
To Him subservient Nature and all confoundedly retort.

21. "O, Love"

I no longer shrink from the challenges of everyday,
For I have already tasted Love yesterday,
Now I manly embrace the challenges of today;
The moments when life seemed fair or unfair,
The agony of defeat and despair,
The joy of triumph beyond compare;
What keeps me continue this cyclic gesture?
It's because of you amidst my every adventure.
Stay, stay, stay, O, Love so pure.

22. "Oxidation Reduction"

All forms in this universe are in cyclic motion
From a tiniest wavicle to the hugest galaxy in any position
In human life, myriad biogenics occur like chemical oxidation
The opposite of which, is a chemical reduction
Tireless elements separate or join together
According to the dictates of Nature -the law enforcer
A bit deviation from it will make us worse if not better.
Within-without, internal-external; processes observed or unobserved.
In all occurrences, "Ba'ba' Na'm Kevalam" is the vibrational sound
unheard.

23. "Parting"

Witness a scene of misery and woe,
A love so pure, hastily did grow,
Too much jealousy let it wear and die,
Accused by the lass of keeping a lie,
And so forced the lad to her bade goodbye;
The two hearts can no more keep the knit,
Parting then is heart-rending sweet,
In proper time and place perchance they'd meet,
In adversities both shan't easily retreat.

24. "Poems"

By a force, poems issue forth and are easily drawn,
From the mind of the Poet, through ink they're beknown.
In the hearts of Art's sentinels, happily they are sown.
Read line for line and make them truly your own.
To your mind as a sword, they will be a hone.
For only with a sharp mind can slice in twain,
The umbrageous Truth and not be in vain.
Together, with a humble heart will't be a gain,
Life, sweet life divine and not a life profane.

25. "The Human Body"

The human body is composed of approximately 100 Trillions of cells
So intricately woven, no one could ever completely tell
That should be taken cared of, not of magic potios or spells
So we can avoid sufferings of discomfort, a hell
Germs such as bacteria, viruses, fungi, and parasites, too
Allopathics... antibiotics of variegated hue
Free radicals of different strength and degree
From these external and internal pathogens, when can we e'er free
Ourselves from the limitations of mortal life(a wishing tree)?

26. "The Most Sacred Truth"

If denuded be, the most sacred Truth;
Divulged and disclosed it off bereft of its filth;
Then one will taste the mysterious, e'er blissful mirth.
If poured be the secret, quenching the holy thirst;
Understand and ask these ultimate queries first;
Who am I and What am I? Let the mind/brain burst.
Stating the interrogatives is the Poet's veritable role;
The philosopher pours words, brimming over a bowl;
Until all is finally dealt with, deafening/muting the soul.

27. "The Social Goal"

Be one with bliss, the Bliss unknown,
Wield a culture everyone can own,
Let people share together, earth's fruit sown;
Shun from the mind, dogmatic doubt and fear,
Remove from the heart with Longhinus' spear,
What darkens the truth, "Everyone's life is sacred and dear"
Know G.O.D., in human nature link'd pole to pole,
One regards the other while the other regards the whole,
Bade self-love extend to the universal, be the social goal.

28. "Your Father Loves You"

My beloved children, proceeding from my loin
In your mothers' womb, you took your wonderful forms
Forgive you me, oh strength of my own groin
For your father's life is a tempest, ravag'd by storms
Heart-rending, mind-boggling: reality is a dual-sided coin
Able not to civilly act the set affirmative norms
May all of you grow in much wisdom and prosper
In your youthfulness, the Maker always remember
And I, your father, love all of you, forget it ne'er ever

29. "True Love Waits"

Oh! True love can really wait.
Think twice before having a mate.
It can never be too late!
Surely there's a proper date.
Let not love turn into hate,
By doing an act just straight,
And meet not the same fate,
Grabbing the temptuous bait
That made lovers regret so great.

30. "Weep No More"

I watched you sleep as you lay down on my side,
Tears fell profusely for the pains inside I hide;
As thoughts of past mem'ries in my mind began to glide,
That like what had befallen me, events will us divide.
Oh! This love of ours plead I not to easily subside,
And withstand the tests of elusive time & tide;
Merging with you in the bosom of unconscious sleep,
I whisper'd to the LORD our love to hedge and keep,
That He'd spare us both and in LOVE no more would weep.

31. "What Inspires A Poet?"

What inspires a poet, a Septon writer,
A doubtful philosopher to reason yonder,
A physicist to find what constitute "energy and matter",
But missing the salient point, the Self... the knower?
T'is naught and futile to aspire for freedom,
If one doesn't feel that life is a boredom,
If one isn't aware of one's slavedom,
And seek what others call, heaven's ruledom,
Not bound by Time, Place and Person's whoredom.

32. "Tears"

They say, to err is human, to forgive is divine.
How will I forgive if the fault is all mine?
Went beyond my limit, stepped beyond the line.
Now, searching for reasons, why it turned this way?
Dreamt dreams, only to give it all away?
Certainly, there is more to know in this emotional sway.
Why love disappears, its warmth turns cold as ice,
Love's flame glows bright and then suddenly dies,
Does it really dies, or turns into tears rolling down to my eyes?

33. "Septon of Mine"

Declared I all what my mind can conceive
Hoping that all people, my point will perceive
In plain words I conveyed, spoke not to deceive
That oneness of Humanity I goaled to achieve
Let this Septon of mine be
The instrument uniting the universal family
Let not you or I survive, but us and we
Together, let's form the holy society
Inculcate to all humans the love of Humanity.

34. "Shadowry in the Sun"

Once I noticed but it's instantly;
I beheld the shadow of my mysterious Me;
Thru the sun's light rays striking and impressing my psyche;
Doubts that cause untold agony are gone suddenly
To the child of Man in all directions and time, race or nationality;
That labour to mete the great heights, magnitude and purity
Of the hidden Man's harboured self-identity;
The sweet Truth alighted after a long and tedious scrutiny;
"I am WHO I AM," the sun disappeared as well as the shadowry!

35. "I"

I have a malady no one can cure.
I need a panacea for it to endure.
I want a relief for this suffering 'yond measure.
I feel so empty though I am whole.
I love (but love who?) that's my cursed role.
I shriek in this kaleidoscopic hole.
I speak up the truth that once had gone.
I see things done being undone.
I know now that I know none!

36. "Easter Spring Blooms"

EASTER shouldn't be
about dead Winter
but victorious Spring
and SPRING is about
Rainy joy of verdant growths
colorful scentuous blooms
and BLOOMS mean Nectar
pollination of Ha Alma
the starting point of creation

37. "They, Dei"

Yesterday, I counted
In front of my pupils
Using my fingers, I started saying
...nueng(one), sorng(two), sam(three)
And then ha(five), see(four).
I was showing the correct number
Of finger/s, they said "You're wrong, Teacher!"
As I was intentionally saying
The different associated word

Last night, I counted
In front of doctors
With words, I started saying
The Whole is dual, one and two
"Yes," said the she,
"Perhaps," said the he
"No," said the voice
An archetypal politics of blunder
Between "They" and "Dei"

38. "The Bamboo Grass"

Of all the grasses
You are the tallest
Dancing with the seasons
Tangoing with the winds

Your perennial presence
Is the village landscape's essence

The musicians you also accompany
Sheltering and protecting the lowly
Feeding even your shoot to the hungry

39. "Off The Rule"

Off the rule you go
Breakin' barriers you know
Yet acts are seeds you sow
Will in the long run grow
As rules others might follow

Freedom is not what you think
As ruthless lawlessness
But following the link
That leads to The Consciousness

40. "Conspiracy"

Did you notice Space and Time mingl'd
At the vast corridor of your mind
It's you they conspire to enslave
By making you believe
That you are growing old
And can't go beyond what's been told
Listen to the whispers within
A secret plot divulgin'
The conspiracy of Truth.

41. "Heart of A Fisherman"

He was walking towards
The wavy shore
When his sole boat
He saw that it's being swallowed
Thus he tried to lift it off
The net on the boat with a rudder he owns

And on the boat he sat for a moment
While his sight was sailing away
He saw the sea in his heart
He was startled by the scene
So he swiftly closed his eyes
And he but was startled the more

Because not only the sea
But including all
Became one in his awakened heart
To him Truth appeared
An unusual experience to him fulfilled
The being that is free and unblemished.

42. "Truth's Embrace"

Truth's embrace is seen as grapple strike by a fool.

By what eyes can it be seen by the wise and unwise
As same embrace and not as strike,
By what heart can it be felt by the affectionate and hateful
As same love expressed and not as revenge,
By what hands can it be done by the noble and despised
As same service and not as business,
By what force segregated the gods, man, and devils
Yet truth holds and embraces 'em together as peers?

Truth they say is great terror of all terrors

Yes, for those who are full of errors
For those whose hearts are in their breast
Yes, for those whose reasons are in their lips
For those whose strength are in their genitals
Yes, for those whose eyes are not one but two
For those who see lawlessness are order
Yes, for those who misconstrue spirit for energy
For those who cannot feel their being True.

43. "Creaution" [Creation=Evolution]

Living is the Creaution
Of Loving;
Vital
Essence of Existing;

Dazzling process
Entanglement in Time
And Space,
Transmeaning
Hyperqualia!

44. "Al-O.n.e."

Your my Vowel
in these narrated essays
Your my Rhyme
in these unmeted verses
Your my Subject
in these objective worlds
Your my Author
that writes mes
Your Mine, Al-One... am you'res.

45. "Graphic Sol'n"

Have you a graph
That'd homeostasize half

Even a half of this brain?
Geometrically [+] illustratin'
The difference 'tween

Real truth and True reality
Within the compass of degree ninety

From Source, Spatial and Temporal
As a vector of real-i-ty >>>>----------> ©

46. "breath"

let every duration
of my breath
impregnate my thoughts
of thee, oh Truth
with pronounced humility
in every inhalation…

grant, o truth,
that this phenomenon
be mastered
and sublimated into love
into a conscious
breath of transmeaning
with joyful apotheosis

and thanatos of my striving
for fame
for power
for vain glory
for pomposity
for extrabanality!

47. "purest pure"

cleared of semantic misnomer
of tropes and figures
and literal no longer
but tacitly pure
such is
an unperturbed finitude
contemplating infinity
braced with fortitude
amidst relativity

48. "Love * Act * Faithe"

do act full O' faith
this is saccharine wisedom
faithe not in the act;

follow the peace thread
leading to The Bliss
reflect, don't deflect!

in time, love -life's light
within and without shall meet
in true devotion.

49. "Juan de la Cruz y Santos"

they gave him names
first, middle and last
then nicks:
for shame, for fame
then bound in oath:
in faith
called religion
called nationality
called race
yet within him
questions remain
what am i?
am i?
i?
yes
no
maybe
perhaps

50. "Q&A"

Q. How long... my buddy
do we have to journey
towards the rich that we are
from the imposed poverty?
Let's walk COURAGEOUSLY
altho' the road is dark or risky.
And no matter how far
as long as you're with me,
and we are as one family!

A. My buddy... you asks how long
but your question seems wrong.
'Cause time like space is just a notion
like poverty you opt to belong!
Let's SAGACIOUSLY walk along
the dark risky road with "BNK" song.
Near of far is just an apparent motion
entangled with a 'being' in a throng
of imagined 'others' like Mr. & Mrs. Ong.

51. "Tomato Riddle"

I come in red, orange and green
In just a season I can only be seen;
I am full seeds and of lycopene
My juice you take to heal your pain;

I also come in different sizes
Small-Medium-Large with surprises;
As paste or sauce, drinks or in pieces
I'm a delight to most, like spices;

I am also called the Love Apple
Because my skin looks lovable;
Raw or not I am on your table
In most dishes, I am the double;

I may not be among the good as best
But I am just happy to be with the rest;
I may be shunned by an honorable guest
Yet certainly I will be in your every fest;
And if you may, I would gladly stay
Close to you until both of us disarray.

52. "Continuum"

Why only four
And not more?
Aren't such design
Hinting the Divine?

Awake, dreaming, asleep
Non-dual trip…

Awareness slips
In seven worlds
Continuum!

53. "the spirit witnesses"

a garden is being smelled by nose

odour is being tasted by the tongue
taste is being seen by the eyes
form is being felt by the skin
touch is being heard by the ears
sound is being reflected by the brain
wave is being experienced by the mind
experience is being understood by the soul

and understanding is being witnessed by the spirit.

54. "ॐ"

(A visual Septon inspired by the work of Dr. Penpen B. Takipsilim, the Father of Visual Poetry)

Am
I
Dot{name}?

Dot [●]
I'm
Not.

I
Am
That (i.e. ahaṅ brahma asmi)!

ॐ

∞

. .

☾

(☉

☻)

(Δ

ψ)

(+

You are
Neither a new species
With a name "Dot"

Nor a word "dot"
Represented by ●
Nay a sound in IPA \ ðɑt \

Not even any of the attributes
The most complex mind-brain
Can ever conceive ∞

55. "Easter Spring Blooms"

EASTER shouldn't be
about dead Winter
but victorious SPRING
and SPRING is about
Rainy joy of verdant growths
colorful scentuous blooms
and BLOOMS mean Nectar
pollination of Ha Alma
the starting point of creation

56. "THE SOCIAL CYCLE"

HE WHO KNOWS HISTORY
KNOWS THE INVISIBLE HAND
KNOW HISTORY OR NOT, NEED NOT WORRY
ETERNAL MANDATES DO STAND.

LIKE AUTUMN THAT FOLLOWS SPRING SEASON
IN HISTORY, EMPIRES DID RISE AND FALL
WHEN A CLASS, TO THE WHOLE SOCIETY, COMMITS
TREASON
THE SOCIAL CYCLE MUST CERTAINLY ROLL.

WHETHER CLOCKWISE OR COUNTER, IT'S YOUR CALL

57. "Truth's Embrace"

Truth's embrace is seen as grapple or strike by a fool.

By what eyes can it be seen by the wise and unwise
As same embrace and not as strike,
By what heart can it be felt by the affectionate and hateful
As same love expressed and not as revenge,
By what hands can it be done by the noble and despised
As same service and not as business,
By what force segregated the gods, man, and devils
Yet truth holds and embraces 'em together as peers?

Truth they say is the greatest terror of all terrors

Yes, for those who are full of errors
For those whose minds are in their breasts
Yes, for those whose reasons are in their lips
For those whose strength are in their genitals
Yes, for those whose eyes are not one but two
For those who see lawlessness as order
Yes, for those who misconstrue spirit for energy
For those who cannot feel their being True.

58. "The Drama"

And when life's drama is coming to its repose
The curtain of oblivion is then going to close
Do reflect and meditate for a moment while.
Is the effort you exerted in acting worth the role?
Protagonist or not, doesn't matter anymore.
Because if it's acted out nicely is always enou',
For it has been cast by Ba'ba' the Greatest Director.
The role we play or act is just a mask
That we take off when we've finally finished the task.

59. "trees of life"

two trees feeding on the same ground
growing together when they were found

years enjoying one sun and one moon
also drenched in the rains of monsoon

throu' them winds blow, hot and cold
they stood together, their roots tightly hold

yet they bear fruits not for each other
not even for a child, mother or father

they are the trees of life: good and evil

60. "Th'English Eight Parts of Speech"

NOUN, pro-NOUN, (you)hear the ryhthmic sound.
verb, AD-verb, a pattern I interestingly found.
"AD" looks more beautiful if to "jectiVE" (AdjectiVE) 'tis bound;
Inject! "jecti" betwixt "INTER" and "ON" -(INTERJECTION),
And connect with "CONJUN", "ctiON" -(CONJUNCTION),
Then put beside "PREPOSI", "tiON" -(PROPOSITON);
Th'English eight parts of speech in septon, grammar and composition.
NOUN, proNOUN, verb, ADverb, and ADjectiVE: can you not yet
trace how?
INTERjectiON, CONJUNctiON, and PREPOSItiON: look, there's
the pattern now.

61. "My Noun"

∞∞∞∞∞∞∞∞∞∞∞

> My noun is a noun(metaphor).
> Pro-noun verbs my object(noun)
> And verbs my another object(noun).

Every time pronoun is with me,
My noun is an-adjective.

> Sometimes, pronoun verbs me with pronominal adj & noun
> And pronoun verbs me verb pronominal adj & noun.

With pronoun, I verbed how verbal and verbal.
With pronoun, I am pronoun-or-adjective.

(Make your own Septon poem based on this by substituting words for noun, pronoun, verbs, infinitives and adjectives)

62. "The Bodhi Tree" (A Trilingual Septon)

He finds, yes, he found and climbed a tree
that extends up from finity to ... infinity!

Surprisingly its twisted roots caught afire.

While 'this' tree 'that' fire did devouringly desire,
its lower trunk unfolds an odorous aurum box.
On it seats an argentum bowl which rocks.

Upon the rocking bowl appears a ruby tetrahedron
touched by a rotating 360° smoky emerald hexagon.
Suddenly all turn'd opal imperative, "HANG on!"

Above its diverging branches A Son of Man appeared.
Handing over to him a red seed and a blue seed.
With an archangel's voice to him He said,

"The red, if you take,
paned reality it will make

while the blue,
joyful ignorance will flood your view!"

SO, he took the last breath and paused
then chose the red which made all Ōz'd

(Ilokano Version)
"Kayo a Baliti"

Nakasapul isona, wen, nasapulna ken inulina 'diay kayo
a manipud ditoy agturong awan paginggaan ... inna panagtubo!

ket al-alun-onen metten ti apoy 'diay nagsirot a ramotna iti apagkanito.

Sakbay a sigsiggedan 'dadiay' agkalikagum nga apoy 'daytoy' kayo,
ket rimsua iti umangot a kahon a balitok iti pinuonna
Nakadisso ti malukong a pirak agbubuwabo idiay rabawna.

Didiay makinngato ti malukong ket rubi a tetrahedro
nakadikket ti agtintinek kasla asok nga esmeralda a hexagono.
Ti apagkanito ket nagbalin nga opalo a baon, "Agkapetka HA!"

Didiay ngato ti agsinsinnina a sanga Ti Anak iti Tao ket immadda.
IyawawatNa kenkwana ti bukel nga asul ken bukel a nalabbaga.
Nagtimek nga arkanghel Iso ket kenkwana kinunana,

"No piliem ti nalabbaga,
nasaem a kinapudno itdenna kenka

no met asul ti inka alaen,
ti nagragsak a kinamaag panagkitam inna paglimmesen!"

'SO nga, immanges ti kauudianna ken nagmennamenna
ket pinilina 'diay nalabbaga nga isot nagpabalin amin Ōz a salamangka!

(Tagalog Version)
"Ang Puno ng Balete"

Nakatagpo siya, oo, natagpuan niya at inakyat ang puno
na mula rito hanggang roon sa walang hanggan ... ang pagtubo!

Biglang tinupok ng apoy ang mga pulupot na mga ugat nito.

Habang 'itong' puno'y manasang tinutupok 'niyong' apoy,
ibabang bahagi nito'y naglabas ng gintong kahong nangangamoy.
Sa ibabaw nito'y nakalagay mangkok na pilak umuugoy.

Sa gawing itaas nitong mangkok ay rubing tetrahedro
nakalapat ay umiikot malausok na esmeraldang hexagono.
Kapagdaka'y naging opalong pautos, "Kapit HA, hijo!"

Sa itaas ng naghihiwalay na sanga Ang Anak ng Tao'y bumulaga.
Iniaabot Niya sa kanya ang butong asul at butong pula.
Sa tinig ng arkanghel Siya sa kanya'y nagbadya,

"Ang pula, kung iyong tatanggapin,
pinid sa pasakit na realidad ay kanyang papangyarihin

ang asul naman samantala,
paningin mo'y lulunurin ng kamangmangang masaya!"

SA pagdili-dili nya pagkatapos ng kahulihulihan nyang hinga
saka pinili ang pula na siyang sa lahat ay nagpaging Ōz na hiwaga!

63. "shoes" (A Trilingual Septon)

arrange your disorderly tools
set aside the rubbish of the fools
so you can know the priceless
from the truly useless
and you won't stumble on these

for your feet to be safe, if you wish
from the perils lying waste
need not let the world wear shoes
a pair for your feet will suffice

(Ilokano Version)
"sapatos"

urnosem dagiti nagkaiwaram a gargaret
ipaknim dagiti inwara dagiti nagutek ti nakulbet
tapno mailasinmo diay kapat'gan
kadadiay awan a pulos pategnan
ken saan a makasikkarod iti pagnaan

no kayatmo a malasatan
nadumaduma a kapeggadan
saanen a masapul a ti lubong ket sapatosam
masapol laeng ti dwa para kadayta saksakam

(Tagalog Version)
"saplot-paa"

iyong sinupin nagkalat mong aguhon't iskwala
at iyong itabi ang ikinalat ng mga tanga
nang matukoy ang pinakamahalaga
kaysa sa talagang walang kwenta
at 'di makasagabal sa daraanan ng 'yong mga paa

kung iyong nais na mga paa'y ipag-adya
mula sa kapahamakang iba't-iba
di na kailangang saplutan ang buong lupa
kailangan lang ay para sa paa mong dal'wa

2. A Septon Flow (A collection of 81 untitled Septons)

It is a collection of poems starting from 6th of March 2014 until 11th of February 2015 that will let the reader enter the world of the author and take a glimpse on how he views a layered world of reality in prosaic or bathosaic manner.

6 March 2014

1.

While surfing the ocean
Of netizens,
Fingers got tired
Of weaving the web

The mind suddenly
Trod the trail
It used to tread
Back and forth
To the dreamland

2.

four corners of the bed
four corners of the blanket
four corners of the mind

seeking peace
from being awake
and trying to quench
it in sleeping
yet nightmares
tire the traveler

3.

in and out breathing
slowly striding the canals
full of weariness

brought by carnal life
trying to grasp
the substance
of seducing shadows

being cast
by the unnamed

4.

waking up
in an unfamiliar environ

confused of how things

happen not
the way they ought to be
suddenly realizing
that the landscape
is just a dream
a dream in a snoring sleep

5.

Sitting unmoved
By nuisance
Of the past
And of the future

I dwell
Now and here

Until nowhere is out view
Because the viewer, viewing and viewed
All magically got lost but not the witness

6.

Trying to make sense
Of time
While glancing
on a wristwatch

A chirping bird
Caught the mind
And flew it away
Into the blue sky
That says it's still daytime

7.

From the window
Bougainvilleas in a row
Bounce the photons
To the windows of neurons

Firing colourful ideas
All waiting for the chance
To free their beings

Of all limitations
Of being grasped

8.

At the dawn
A dream pulled the mind
From waking up

The novice meets
The Preceptor's embrace
Instructing the former to continue

Not minding the conflict whether
Who should or not don the ochre robe
But the alarm decided who'd wake up

9.

Stretching, contracting
Twisting with pause
The alternate in-exhalation

Mind reaches out
For the equilibrium
Through the body
Of concepts
Hidden in animals,
Trees, and posing flowers

10.

After washing away
The daily filth
Accumulated by labor

With earth's nectar
And scented essence

The purified body
Bows down in oblation
offering multi-coloured lotus
to the Supreme

11.

A quarter of the day
Only the voice
Of the fingers
Is being heard

While mind ruminates
Of benign inanity
Of hypnos and thanatos

Following the hint
Breathed by the Master

12.

Mind seated in a posture
Enumerating the ephemerals
Cogitating of cognition
Rendering itself powerless
Awaiting for an iota of grace
Longing for the Beloved
To come and bestow
Even just a glance

Yes, a glance into a mirror

7 March 2014

13.

Body and alarm temporal
Harmonize the internal and external
Keeping pace with the astronomical bodies
Waking up dormant propensities
to move the social wheel
on individual and collective aspects

The individual merging with the non-dual
The collective entering into pacts
Realizing a dream of a great universe

14.

National anthems are now obsolete
Continents drifting apart are bridged by ports
Like temples bridging the mortal
With the Immortal One

So individuals must learn
To systematically submit
Apparent separate existences
To a greater cause
For Humanity to continue

15.

Submission
To the Supreme Consciousness
Is unveiling of ones subtlest cognition
And is emancipatory

Submission
To an Exploitative Highness
Of a machinized nation
Is Slavery

The two are incompatible

16.

Reading a page on atheism

Mind asks: 100-3 = ?

Can the experience
Of having heal'd a hundred
Except three
Be a valid reason
For not having faith
Or go on believing
Mind's power

8 March 2014

17.

Survive the fear, let it flow and pass
Forgive the guilt, blame not others or you
Willfully shun shame, release the past
Grieve not, love instead and let the pain of loss go

Lies lead to truth if you admit and deny not
Illusions are insightful if you can untie the knot
Crude is the Spirit solidified by the Power
Your attachments, to Bliss surrender

You are the Whole without a hole, none other

18.

Let's cross over
Oh my soul
Bear with me my mind
Hold on the rudder and balance

For the boat will now glide
On the wavy ocean of life

Following the sunset
Gathering all the lights
To light the voyage onto immortality

9 March 2014

19.

Sometimes
Losing equilibrium in heart
Is finding the center of a circle

Like transcendental numbers
With befitting beauties of asymmetry

Unknowns are determined
By being unwhole with percentile
That don't possess last digits

20.

Don't
envy the sun
touching her skin

Kissing
her rosy lips
with warm affection

While her eyes
are glimmering
with so much love

21.

It's Sunday

Is city
the choicest place to go

Or stay like the mountains
and listen to the birds
as they fly over

The sky
Of awareness

22.

Why only four
And not more?
Isn't such design
Hinting the Divine?

Awake, dreaming, asleep
Non-dual trip…

Awareness slips
In seven worlds,
Continuum of experience!

23.

Habituated devotee
Expecting unconsciously
Of a habituated daily ritual
To take place
But is dismayed

For the ritual wasn't observed
Today the priestess
Was summoned
To prepare for the Equinox

11 Mar 2014

24.

A beast chose digging
Everything from Geomancie,
Heading into Jove's kiss

Leading man's noetic ontological
Philosophical quests… ruminating

Sublimating
To unify
Veritable wisdom's xylem-phloem
Yonder zoetrope

25.

Infinitropic interlocked dimension… y
Actuality as cathedral of lights
Mystically nurtured nature
Layers of kaleidoscopic
Shaded livingness… o
Devolutionally evolute
Dyed deadening deaths of
My "I" from forms and names
Transmeaning throughout times… x

12 Mar 2014

26.

five factors meet
in a body with feet

the fifty propensities
going to four cities

to quench the thirst
the physical first

then psychic second
third psycho-esse bond
pass space-time… go 'yond

27.

heaven is hell in here
where men play gods
whom the poor fear
and cannot go odds

upon finding that time is not
space the same, just a plot

realize what you once knew
a hidden secret, a being within you
that ne'er grows old but is always new

13 Mar 2014

28.

protect the brain
with loving skull

surround the pineal
with loving neurons
disciplined bones

and nourished muscles
be loyal to the senses
the rest will be as heart
and not as bowels

29.

perhaps
what is perceived
is interpreted
in a manner
tainted
by instrumentia

that the eye
see happiness
juxtaposed to suffering

14 Mar 2014

30.

(Yesterwhile checking English lines)
In Siam classroom...
Suddenly, my ears heard me
Speaking Visayan words
"Kinsa na?" (Who is that?)

Not confused, yet amused.
My Ilokano tongue asked,
"Sapayen?(What's happening?)

The awareness switched
Shocking the murmuring pupils!

15 Mar 2014

31.

Man
Wants to know infinite
Because he is INFINITROPIC
But has finite time

Does not even know
What is it that he knows
Because of IGNORANCE

And had forgotten
He is woman

32.

Be Chao Phraya that's just going,
Does not suffer of angsting
Of the suzerainty and the sheepling!
Does not suffer of spatial
And temporal,
Maybe mystical?
Does not care of red-black
Or is aware of yellow-white, not slack

But actively inactive... engulfed.

17 Mar 2014

33.

A nillionaire
In a null and void world procuring emptiness
To quench infinitropic meaninglessness
Having nothing but cipher and zero

I am being
I am bliss
I am awareness

I'm
No-thing

20 Mar 2014

34.

This emptiness
Fills my false being
With layered falsehood

That prevents awareness
From seeing
The good

In consciousness
Yonder mortal living
Of this unit-hood

34.

My reined horse
Takes me
To where I want

And my sharp facón
Slices truth from false

A job others boast
I know not

I ride beyond time
And frontiers

35.

Quixotic romance

In chaotic relations

Quixotic wars
Of psychopathic lords

Quixotic aspirations
In miragic paths

Quixotic wealth
Of impermanent tangibles

All in a Quixote de la Magic world

22 Mar 2014

36.

Before the sun sets
From my eyes
Let me take a glance
At your sweetness

Break your smile
Once more
And ease the pain
Of letting go
These illusions

37.

These illusions are real
You made it
So you may hold me

Come now
Sing me a song
As you caress
My face

Memorizing every detail
You yourself imagineered

38.

Why did you leave
Without even saying goodbye
Without reassuring me
You would come back

In my dream
You'd speak words of love
That linger even when
I'm already awake

Like Venus in the dawn you turn into Sun

39.

The leaves of the trees
Are now budding with hope
Giving a shade of relief
To a scorched soul

I know you'd never forsake
The love you once knew

When flowers start to bloom
You will come like a bee
Thirsty for the nectar of love

40.

The newly painted wall
In pinnnnk
Reminds me of your rosy skin

Soft as rose petal
Scented forever
In my mind

Tonight we'll meet
In the sweet embrace

Of dream

41.

Like Crimea to Russia
I will take back what's mine
The memories of shattered love
I will at all cost resuscitate
A Kintsugi of broken dreams
From turmoil and envy
To immortalize
What's ought to be

To love while everybody hates

42.

Share me
Your deepest thoughts
While we spend the rest of the night
At the corridor of romance

While gazing at the stars
Let us burn together
In the flame of love

As we join in ejaculation
The mazzaroth above

23 Mar 2014

43.

You gave me a reason
To keep
Me coming back
Here I've become a sun
That sets
and rises on

Five points, in three directions
I hover
watching you safe

2 Apr 2014

44.

You called
My name

That night
You came

Oh You
Whose fame

Of yore
is aim

Of kings

12 April 2014

45.

Rushing winds unwind
Came to hug me

Leaving behind
A fallen tree

And in my mind
A buzzing bee

stung so unkind
unleashing a propensity

of compassion

46.

I'm swimming
throu' life shows

A sea giving
harsh blows

I don't know knowing
and how life grows

But that's the way it is

So I just go on living
along the tides, highs-lows

47.

With just heart
head and hand

I'll tread this art
of (Stealer of mem'ries)Suprabrigand

that beacons to start
anew, and

define life apart
from any but just a profound
...experience

17 April 2014

48.

it all began that day, that's tomorrow
in the calendar, two decades and 8 ago
not in a blood moon night like the day
before yesterday

i felt you in me, your heart forlorn
the wounds caused by the thorns

in the holy writ were scribbl'd
by those four apostles named

but did not the sins of this world

49.

and i became whom they've called
the little doctor of the young and old

amazed by the effect of virtue
that flows from You

when i assume the form of a healer
dispelling the maladies others' suffer

i know it was You and not me
that made them whole and be
as they are when they're healthy

19 April 2014

50.

last night
I saw dogs
caught in a net

while
many kittens
try to cling on me

it wasn't
but this morning

waking up from a dream

24 April 2014

51.

O, CruElle One
you hap'ly bestow
with your right
and claim it back
with your left

leaving me confused
in hallowed emptiness
unable to comprehend
and standing as a holed

52.

In the name
of Poetic License

I will as a grammarian
keep my silence

At the back
of sham innocence

I will as a teacher forget
that I was a student once

It's sacrilegious med'ling with others' peace

1 May 2557

53.

let's labour and sow
actional feelings and know
by bending the bow
obfuscating not the arrow
uncover -above is below
rekindle the flickering glow

dimmed by life's flow
alienated in capitalist's show
yet as we labour, we grow

4 May 2014

54.

merging with the ground
bidding adieu
to the leaves still clinging
onto the branches
of the wish-fulfilling tree
fed by xylem
and phloem of desires
rooted in an abiding earth
while blown by wind of change

5 May 2014

55.

The Great is with me, i may be...

the tiniest
among the grasses
the minutest dewdrop
in the morning
smallest wavicle
in an unknown field
a mere idea
in the holocosmos

56.

is there no hand
for May's lad

to hold on to

when caught
in the quicksand
of despair
when the square
and compass

are both lost

11 May 2014

57.

mothering isn't about child-bearing
or even about physiological gender
that all children know. it's a quality
honing every childlike characteristics
embedded in all born children of the world;
rearing the delivered unfolding entity-
inertial-istinctive-intellectual-intuitive;
nurturing every conceived goodness,
greatness, and M-hood in all.

14 May 2014

58.

O' Thou
'who' shelters all

'how' art Thee
being sheltered
in all?

By Thy Power
Thou force
Thy strength
so that energy
manifests in mine eyes
reverberating Thy sweet Name

30 May 2014

59.

churn the elixir of contentment
from the waves of four-petalled desire
in the ocean of essential events
and feel the joy of not accumulating
the inane things of 'this' life

drink THAT dulceous devotion
from THE DEVotion incarnate
oozing from the name-form
healing the dullness of tasting love

31 May 2014

60.

The void I unknowingly made
Is now filled with emptiness

A space made of gaps
woven into a tapestry
Of inanity

Now I am lost in 'this' labyrinth
Of nullity, trying to decipher
Shunyata of buddhahood
And regain no-thingness

07 June2014

61.

what is this
play of time?

"i was reborn
a decade 'fore my death!"

others shall soon see
how shall my frame
fall on the ground
embracing my i'mmortality

12 June 2014

62.

Luminosity is the eye
of blinding warmth
which will enkindle the feeling
that will untie Freedom

Stupidity's knot
can be untied by bright
shimmering Light

between Hatred
and Love

15 June 2014

63.

clouds above the rooted trees
accentuated by blue sky
while birthing stars
lurk behind the hue

dark errie space 'yond
enveloping the dying stars
conscious torus
wields dark errie full space
taking back all that's been given

25 June 2014

64.

Why struggle as man
when you are
no longer {one}
●
◻
○
You have now
be~come
...Ahhh child
*

*

*

of i$htar begotten by €£0H%M
borne out of a 'cry' nurtured by feigns
You are Pepi, not Pepe!

27 June 2014

65.

at the edge of 'this' known 'me'
a voice keeps whispering
wiping away my fiery 'eyes
'full of tears
rolling down
wetting the earthen'd memories
causing dreams to bloom
spreading scentuous hope
and oozing with nectar of love

28 June 2014

66.

a feverish cup
kissing his lips
precipitates redness
of the wine

smearing colours
of ayát...

overwhelming
the coldness
of the solstice rain

28 June 2014

67.

packin' all
sweet memories of
bitter struggles
by the bank of the river
flowin'through
the land of siam
while contemplatin'
on beloved asia
in the vast universal 'how'

29 June 2014

58.

Due to hyperopia
You had moved me
into vast Expanse
just to view You
the essence of Beauty
through me clearly
in the mirror of Eternity
Eye saw You, eye fell in love
dispelling the malady

1 July 2014

59.

spinning 'round
suspended

seeking peace
seeming endless

shattering limits
shackles of meanness

stars are laughing
shades of blue
shape my world

70.

Cloud is like moon
that waxes
and wanes;
Like the sun
that hides
when it rains;
Like all else
We do,in time, change.
Nothing stays, but only love remains.

71.

it's rainy season
and industrious ants
saved a lot of crumbs
while the poor proud moths
that are attracted by light
proudly fly throu' death

enriching the earth
of evolving carcasses
like unheard martyrs

5 July 2014

72.

crystal needles
falling on the earthening cognition
...awakening
the feeling of elation
...light dawning
announcing victory's arrival procession:
hail, hail, hail, the viceroys
of love!lia fail coys like dove,
dale bows to royales in receive.

31 July 2014

73.

'me' got lost
lookin'
for the boundary-node'
tween time & space...
aboard the Enterprise
navigated
by one who cares only
of transporting a passenger
from point A to B.

1 August 2014

74.

¿ Can you
square
the circle
of Tri-angles
in 'thïs'
holo-fractal
Locus
of 'Thât'
...Vol. less 7+2

30 August 2014

75.

.tsid
.t'vom
.time &
give 'us'
idea 'we'
dis-connect
connect
as unit < >
uni-versal

09 September 2014

76.

... fruit
of my being
... strength
of my loins
... joy
of my struggle
... hope
of my labour,
have i father'd you in vain?!!!

6 October 2014

77.

let...

the distance
between us remain

and ignorance
divide us in pain

and this romance
with bitter refrain

will soon in just a glance
evaporate after the rain

7 October 2014

78.

a you saGe are
+
if known you,ve
a is not purepl violet
+
that is voilet real
purple and unreal
+
th7 violet is colour
while blu-rede purple
+
that fries isn't pie
fran isn,t americench

31 October 2014

79.

why, oh ocean, you swim
against the wobbly current
or with it willingly

...you feel
the coldness
of water's warm embrace

...you see
yourself alone
taken aback by wearisome waves

11 February 2015

80.

The WAS i SAW
Do LISTEN to
the SILENT zodiac.
They TEACH, how
to CHEAT, in time
The LEADERS, who
are DEALERS, in place
Of WAR where
RAW starts come.

81.

i beg thee, stay with me, oh ever dearest Companion!
stand by me, though i may not emerge as the champion
look, the night is still dark and my torch is growin' dimmer
the path is full of danger and my strength's gettin' weaker
please, i know i may have forgotten thee for a while
for this journey is indeed mesmerizingly full of guile
forgive my misdemeanors and my stubbornness
that sometimes cloud the clarity of my awareness
only You in me can make myself be-come You That I AM

3. Selected Septon Poems from other Septonists

1. "Taxing To Death"

Taxation is the purest of political games
The process determines
Who gets what, where, and when

Smith (Adam, that is) warned
If taxes were onerous
Mobile capital can frustrate avaricious princes

Taxes are sure as death
Lennon and McCartney crooned
Dead men must declare the pennies in their eyes.
-Prof. Amado M. Mendoza, Jr. (a.k.a. Crazy Horse)

2. "FOR THE LUNAR NEW YEAR, 9"

The golden ball floats over the sea,
I approach, to set my poor self free.
The sea is wide, I want to belong.
Water does not frighten me today!
One step, and the ground is no more felt.
If you ever feel a need for me,
find me, then, among the angry waves.
Lie your back upon the white-sand shore -
I will be there, roaring at your feet.
-Mr. Joven A. Ramirez (a.k.a. Mariano de Sangreorojo)

3. "Reliquary"

Gushing forth like a river
It pours incessantly
Filling in the cobwebs
That were set forth
Erasing the remnants
Of the forgotten past
Easing away the loneliness
That was woven
Intermingling the then and now
-Ms. Khadijah Maricar Bulawin (a.k.a. Raci Niwa)

4. "Point-Dot"

never be proud
of whatever you have

because riches and all
are only specks in life's wall

and even if you are the greatest
in the whole universe

in the eyes of the Creator
you are just a dot on His floor

just like me, him, them, us...
-Mr. Ronald A. Marzona

5. "Mystery of Beauty"

........the...........'B'..eauty....................A young child am I searching
........butt.........'E'...rflies....................Watching the rainbow colored
.......... gr..........'A'...cefully...................In the green meadows dancing
.......of bl..........'U'..e skies.................(Listening to the dear word)
..........tha.........'T'"..s worthy...............(For I know I'll find something)
....... myster......'Y'........................... ...Far beyond (the unexplored)
.......as time fl....'I'..es........................What will be left by the flame
........ paradi......'S'..e?...................... And will the world be the same
-

.......... winki.....'N'..g eyes................. Things that are perceived by our
......... real st....'O'..ry.......................... Hide the truth and the unknown
........b'fore i....'T'..dies......................(One day, we will see the pow'r)
......blurred,....'S'..hady......................(Amid darkness, light is shown;)
..............spr.....'E'..ads and shines.......It glitters (in stolen hour)
... in dark lin.....'E'...s...........................The brightness is over thrown
......but in mi....'N'.. d....................Beauty rests not in the eyes
..........deep.....'B'.ehind....................Not what you see but what lies
-

..............that.....'Y'..ou see.....................It's not in the appearance
...........to no.....'T'..ice...........................Thine eyes can ere; thus can fail
.................s.. ..'H'...adows flee.............In a sudden (blink or glance)
.............. th......'E'...stories...................(It's the mind that can unveil)
.......you ar......'E'...free....................(It's a choice and not a chance)
.....of beaut......'Y'...............................Discover the puzzling tale
..........differ......'E'..nce.......................Weigh the things and find the sole
.............exi.......'S'...tence....................Know the secret of your whole

-Mr. Mac Adrone T. Adonay

6. "One More Time"

In the middle of the night I cry,
And I cannot help it but sigh,
I know I dreamt about you,
Just don't know what to do,
Tears begin to fall,
'Coz you are gone,
Far away,
One more
time.
-Ms. Annabelle T. Cahanding

7. "You Are Beyond Compare"

Why am I neither rich nor handsome, you wondered?
You are very rich and handsome, I answered.
Your character glitters like silver and gold.
Your wisdom is as colourful as the rainbow.
Your intelligence is as brilliant as the stars.
Your understanding sparkles like sapphires.
Your face shines like many precious jewels.
So, there is no other richer
Nor another handsomer, my brother.
-Ms. Jeannie Carrera Chow

8. "Walang Pagitan"

AKING winiwikang ako'y nagaasam
Hugis Niya'y hanap na tunay na tunay
Itong nalalasap Siya ang may alam
At wala nang ibang magbibigay linaw.

IHAHAYAG ko ba ang ganitong lagay?

AKO'Y walang anyo sa Kanyang harapan
Ngunit sa loob N'ya ako'y nananahan
At dahil sa akin Siya ay may Buhay
Sa puso at puso na walang pagitan!

(English Version)
"Nothin'-in-Between"

I am saying that I am desirous
His veritable form I truly seek
Only He knows what I am feeling
And no one can elaborate further

WILL I DECLARE this state of BE-i-ng?

I am formLESS in His presence
Yet within m.e He resides
And because of me He has l.i.fe
Heart(to)heart where nothin's-in-between!
-Mr. Manuel C. Ambrocio

9. "Optimism"

Humming love song
Writing poems of heart aches
Indulging myself to optimism
Ah! Relaxing point of view

I should have done these before

Dancing from the melody of my poems
Sorrows are now gone with the emptiness
Shining through the tears of happiness
I am free from being a slave of loneliness
-Olivetti Millado

10. "Free Spirit"

Wandering and wondering
Yielding to the Divine Will
Free and spiritedly aware
Of changing blissful moments

Anchored in abiding grace
They are riddles to be understood
Free spirits are guided in the ways of truth

To others, they are metaphors
Bound yet free to roam the earth
-Mr. Roy Mark A. Corales

## 11. "Paraiso Ng Puso"...............	"Heart Paradise"

Naglalagablab na puso...Fiery heart
Damdaming sumisilakbo................Surging feelings
Pag-ibig na nakapapaso..................Love that burns
Init ay umaalimpuyo.......................Heat whirls
Tagos kaibuturan nito.....................Piercing through
Ningas, apoy na alipato.................Flame, fire sparks
Tila ba nagbabagang yelo.............Like ice ember
Pagmamahal wagas't totoo...Affection eternal and true
Apoy sa dagat Paraiso.Fire in sea of Paradise.
-Corazon De Luna

12. "Flow"

Flow down the drain
Your hatred and pain
Whistle it to the wind
And let it vanish to the air.

Life is too short
To waste on anger and discomfort
Leave unhappiness behind
Live in peace all the time.

We'll all be back into dust anyway!
- Ms. Gemma P. Duldulao

13. "Shining Star"

Gazing at the shining star at night
Adoring its twinkling sight
Slowly closing my eyes from its light
To feel and embrace it tight

Cold winds rushingly flow
Brought me in deep sorrow
Like falling leaf from its bough
Gasping to survive the blow

All along I almost surrendered, but I fared!
-Ms. Joey J. Fernandez

14. "To Travel With You"

Would you take my hand so tightly?
To travel to a place we've never been?
To travel the longest journey with you,

Will you fight for me in the lost desert?
To walk with you on a zigzag road of life,
Will you hold my hand in the darkness?

Through the end of what we are heading,
We light the torch to make a fire flame,
It is the way to happiness of surviving being.
-Ms. Francis De Chavez

15. "DEFINE LOVE"

Many say that, love is a mystery...
It comes from up above
Molded in secrecy
Love comes in form of a morning dew,
A melody..
A child's laughter..
A cool breeze
A gentle rain
A rainbow
An echo...
A glance from afar..
A tap in the shoulder
A smile
A hello,
A goodbye...
Whatever love is..
Remains a mystery..
Nobody can define
-Ms. Carmencita S. Aquino

16. "TEARS OF SILENCE"

in silence ~
when words are not spoken
listen to your heart.
let go of your tears
to wash mask of doubts & fears
that cannot speak
with amazing grace;
when veiled with hypocrisy
that won't make you see.
-Mr. Roberto J. Calingo

17. "My Waterfront"

i have composed
a little journey of joy
snippets on the tiny sands and waves
on my feet
i have seen
the hinterland's trance
i have gone
to the waterfront
of my genesis
-**Ms. Caroline Nazareno (a.k.a. Ceri Naz)**

18. "LET IT FLOW"

Let it flow,
 Like a flowing
 river of dreams
Let it fly,
 Like a multi-coloured
 wing butterfly
Let it sing,
 Like an angel singing
 in the clouds
Let it fall,
 Like falling tears
 of happiness
Let it pour,
 Like a pouring rain
 in the garden of love
Let it dance,
 Like a dancing green
 leaves of tress & plants
Let it,
 let it be, let it flow
 let it fly, let it sing
let it be
 let it fall, let it pour
 let it dance,
 Your mind,
 your heart,
your soul,
-**Mrs. Aine A. Losauro (a.k.a. Ligaw Makata)**

19. "insatiable"

they want to hold
the best of both worlds;
and control the universe
them, 'demigods' who always want
while having it all

still, there are those who scamper
to provide, to please; that often
relationships and dreams
are left to rot, to scatter.
-Prof. Alexander S. Cruz

20. "pnaa g utur agn"(Bikol Language)

pangaturugan pangaturugan pangaturugan
naglakaw-lakaw sa baybayon
binukod kan maitum na panganoron
binukod an paghangos
bako bako man panganoron
delubyo delubyo delubyo
mata na mata na mata na
lumang bareta gadan
pnaa g utur agn

(English Version)
"s h a dre a tte re dm s"

dream dream dream
seashore stroll
nimbus chased
chasing my breath
no not nimbus
deluge deluge deluge
wake wake wake
old news wake
s h a dre a tte re dm s
-**Mr. Franco C. Sangreo**

21. "Mangnganup" (Ilokano Language)

danapeg mangnganup;
nangbibineg
'ti abut dagiti bao!
nagtayyek ti lubong:
Simpeg kali-
Naklep dagiti mangnganup!
napasag ti bigat,
ta inabak ti rabii
raniag init!

(English Version)
"The Hunters"

the hunters' cadences;
slowly crawling
the hole of unsuspicious mice!

the world was in a spin:
eagles attacked--
the desperate yielding hunter!

and the morning lay down,
because the night was assailed thus
by the sunlight!
-Mr. Oswald A. Valente

22. "Sisters' Universal Joy"

joyous moments
burst of spontaneous laughter
child-like painting
back to classroom
tools empowering life
physical, mental 'N spiritual.
Engulfing hearts with pure sweetness
Wide smile radiating love from within
Beauty and joy FULLY COMPLETES
-Ms. Parameshvarii Linda May

23. "Nail Clipper"

In order to shave
My own silhouette
I cut a nail.
Into the dark night from my fingertip
Misery thrown away
Its moon is a double-edged crescent.
In order to bury
My roots of tears
I look up the empty sky.

爪切り

自分の輪郭を
削るために
爪を切る
指先から闇夜に捨てた
侘しさの
月は両刃のクレセント
涙の源泉を
埋めるために
空を仰ぐ
-Mr. Hiroshi Taniuchi

24. "Prayer For Rain"

Ai yeo ah!
Tie kong, Tie kong!
Please help, please help!
My nose is watering,
My eyes are watering,
My head is pain-ing,
Somewhere is burning,
No rain is coming
Haze joyfully swarming.
Oh Tie kong! Oh Tie kong!
I can't see you,
I can't hear you,
I can't feel you,
It's too hazy,
Plants and Animals are dying,
Human & animals are crying,
Do bestow us some rain,
I'm struggling to breathe lao.
-Ms. Sunanda Eng

25. "Peak: of the midnight"

Moonlight is getting dimmer
To someone; who stays awake at night
Waiting for the late hours
That will try to tempt one
Insinuating; a peaceful sleep.
Eagerly waiting for somebody to arrive
Midnight's smile, will be disturbed
Dissipation will shed off
Peak will wake up!
It can never complain
Taking off the veil
Of thick cloud; disappearing
Pulled by the blow; of envy..
Peak ; of the midnight
Desire will moan on the lap
The eyelids' closing in the night, will caress
The wonderful breast
Then on it will wavingly drink
-Mrs. Josie V. Rituerko

26. "Flower"

You're my beautiful flower
In this wide garden of mine
With sweet scentuous odour
Every time the sun starts to shine

A flower always in bloom
Having colours that are bright
A beauty that does not fade
When I embrace you, I'm whole
Oh beautiful flower of mine
-Joy G. Gallardo

27. "Love"(A Septon in Five Languages)

(Original Version)

When i had come to know you my love
Knew then that it's love had found me
Looking deeper found more truth
That without even looking
And without searching
Love is in me
You and I
Are One
Love
-Ms. Ainjali Chow

爱

当我知道你是我的爱
当时知道爱找到我
寻找更深现真相
其实无须要看
无需搜要索
爱是在我
你和我
是爱
合

- translated in Mandarin by S K Tan Sanjiti

"Ài"

Dāng wǒ zhī dào nǐ shì wǒ de ài
Dāng shí zhī dào ài zao dao wǒ
Xún zhǎo gēng shē xiàn zhēn xiàng
Qí shí wú xū yau kàn
Wú xū sōu suǒ
Ài shì zài wǒ
Nǐ hé wǒ
Shì ài
He'

- translated in Mandarin PinYin by S K Tan Sanjiti

"Cinta"

Ketika ku kenal tahu bahawa Kau adalah cinta ku
Tahu bahawa Cinta dah temui ku sejak senjakala
Sedar dalam ku mendalam dedah lebih kebenaran
Walaupun tanpa ku menimbang atau melihat
Dan juga tanpa ku mencari
Cinta dah didiri ku
Kau dan ku
Satu bergabung
Cinta
- translated in Bahasa Melayu by Ms. Ainjali Chow

"Ayat"

Idi kanito a naammoanka, o inkapkapnekak nga ay-ayaten
Naawatak nga iti nakasarak kaniak ket ti ayat
Idin amirisek, naawatak ti naun-uneg a pudno
A saanen a kasapulan a sukimatenen
Kasta met, saanen a sapsapulenen
Ti ayat addan kaniak
Sika ken siak
Maymaysa nga
Ayat
- translated in Ilokano by AWH

"Lugud"

Iniang antimanung akilala da ka, o jo kaluguran ko
Ikit ku na ing pamalsinta ing menakit kanaku
King panamdam, ikit ku ing bayung katutuan
'E ta' na kailangang pakibaluan pa
At agiang 'e ne panintunan
Ing lugud atiu kanaku
Ika ampo yaku
metung mû
lugud
- translated in Kapampangan by Mr. John A. Balatbat

"Pag-ibig"

Noong sandaling ikaw ay aking makilala, o aking irog
Nabatid kong ang nakatagpo sa akin ay pag-ibig
Sa pag-arok nito, natamo ang ibayong katotohanan
Hindi na ito kailangan pang saliksikin
At kahit hindi na hanapin
Pag-ibig ay nasa akin
Ikaw at ako
Ay iisang
Pag-ibig.
- translated in Tagalog by AWH

"Aro"

Nanlapu nen akabkabat ta ka, o inar-arok ya tugtua,
Naantaan kon tugtuan aro so akaanap ed siak.
No nonoten ya maong, naantaan so katugtuaanto,
Ag la ya kailangan ya anapen
Tan ag lan kailangan aralen
So aro wala'd siak
Sika tan siak
Saksakey ya
Aro

- translated into Pangasinan by AWH

4. Kúryu : the Septon Sub-type

Kúryu is a sub-type of Septon and designed to suit the tastes of short poem poets.
The term means "the way of nine." It is also the spliced syllables "ku" of haiku and "ryu" of senryu.
It is composed of 18 syllables distributed in 3 units/lines as 4-6-8 that can be intershifted... 6-4-8, 8-6-4, 4-8-6, 6-8-4, 8-4-6.

1. 18 syllables >>> intershifting measure 4-6-8
2. has the haiku-senryu characteristics and beyond
a. symbols (now, season, feelings, satire, things, etc.)
b. cut (anti, pro, sync) *can shift place
c. unrhymed/rhymed (aaa/aba/aab/abb)
3. uses punctuation marks 'nd diacritics
4. uses numbers and caps letters as ideo-visual effects
5. local colors
6. fictitious or experiential
7. may be formed into a Septon
*8. may shrink to 4-6-8 letters as compact Kúryu
*9. may break the above rules and still call it Kúryu as adventurism
-awh

5. AWH's Kúryu of the Moment

1. "enlightenment"

the three-fold light:
luminous hot and fiery;
purging love into devotion.
~AWH

2. "mathemathesis"

i started counting the numbers ---
oNE up to tEN;
another's added... nOne.
~AWH

3. "meditation"

the fifth among the notes ---
is now calling;
"come, and let us now meditate!"
~AWH

4. "labour"

'heard his murmur,
he, an enslaved proletariat:
"where's my just salary?"
~AWH

5. "unification"

the two charcoals ---
fiery embered feeling;
the gold tortoise beetle roasted.
-AWH

6. "rossana and kristel"

busilkay' nga apagukrad ---
dimteng tikag;
ti daga ket napanesan.
-AWH

7. "global climate change"

hovering around a flower---
a confused mosquito:
'tis a wet leaf?
-AWH

8. "false ego"

i am stairing up ---
the bubble which is ascending;
nuh, it is gone!
-AWH

9. "all souls day"

the colours of the past,
marigold ---
will you still remember me then?
~ AWH

6. Selected Kúryu

1. "sagacity"

blessed are souls,
comprehending all situations:
3, 6, 0 degrees
~ **Ms. Ainjlai Chow**

2. "loneliness"

clouds are gathered
in the vast sky of loneliness
raindrops falling like beads.
~ **Mrs. Aine A. Losauro (a.k.a. Ligaw Makata)**

3. "relationship"

three elements fire has,
fuel, oxygen and heat;
put it out, remove one.
~ **Prof. Alexander C. Samson**

4. "creativity"

inside the box,
are more than four corners
shapes, angles, lines without borders
~ **Mr. Mac Adrone T. Adonay**

5. "affection"

will you sing the song, please?
o, nightingale ---
the offering of love.
~ **Ms. Gregoria B. Glorioso**

6. "desire"

I'll denude-dream;
And I'll pierce it with love -->
And offer it to your altar…
~ **Mr. Marlon A. Rodrigo**

7. "offering"

O, you our father!
the all beneficient;
ours is the doing and action.
~ **Joy G. Gallardo**

8. "invitation"

what a sweet voice ---
I enchantingly heard;
an ancient chamber which is closed.
~ **Mrs. Ven-Lyn V. Atiagan**

9. "admonitions"

admonitions…
from our progenitors,
must be followed religiously.
~ **Mr. Allan V. Sasotona**

About the Author

Ajarn Wu Hsih (a pseudonym of **Josefino Casco Jimenez**) is a poet who was born in the Philippines.

He completed his Bachelor of Secondary Education (major in English Language and minor in Mathematics) at the Central Institute of Technology in 1996.

At a young age, after a mysterious event took place, he turns into a healer and he found himself treading a path of a healing mission. While doing his healing mission he begins working as an Account Assistant in the **Rural bank of San Juan** in Paniqui, Tarlac after earning his degree. But his deep thirst for spirituality compelled him to leave his job. In the same year, he finds himself on a ship going Mindanao and landed at the gate of **Prashiksana Matha Asian School of Intuitional Science** in Davao City and enters as a novice in Tantra Yoga under the supervision of A'ca'rya Shanta'tma'nanda Avadhuta until 1998.

Two years later, he returns to his hometown and took the **Licensure Examination for Teachers** and **Civil Service Commission Test** and receives his Guru Certificate then practiced his profession as an educator in private school as well as in public school.

While teaching, he dabbles into poetry and on the 18th of September 2007, and begins writing poems which he named **Septon**. In the same year, during the **Maharlika Sunrise Festival 2007** (the only roving annual festival being held in the Philippines) held in Baguio City, his

Septon poems were first read in the literary workshop organized by **Maharlika Artists and Writers Federation**.

During his 35th birthday in 2009, he leaves Philippines and taught in the Kingdom of Thailand where he continues to exercise his profession up to present while weaving this book.

He is a delegate in **Pentasi B Forum and World Friendship Poetry Celebration** 2013 held at the Marble Hall in the National Library of the Philippines and a recipient of **the Pentasi B Inspirational Poet Award 2013.**

He is a guest speaker in the **9th Nakem International Conference/1st Congress in Ilokano Language 2014** held in Baguio City, Philippines where he read his Septons in Ilokano Language which are also published in the annual Nakem Papers.

For him, poetry, like yoga, is an art that develops the aesthetic senses and supra-aesthetic faculty -a necessary faculty to understand one's own being.

This book is a fruit of his experiences, a facet of his Septon Flow ~~~ ~~~ ~~~ of life.

Printed in the United States
By Bookmasters